MISTY COPELAND

For Misty,
whose dreams are all
coming true, as she has become
the first African-American
female promoted to principal
dancer at American Ballet Theatre.
You are inspiring so many
to dream big!

—Richard Corman

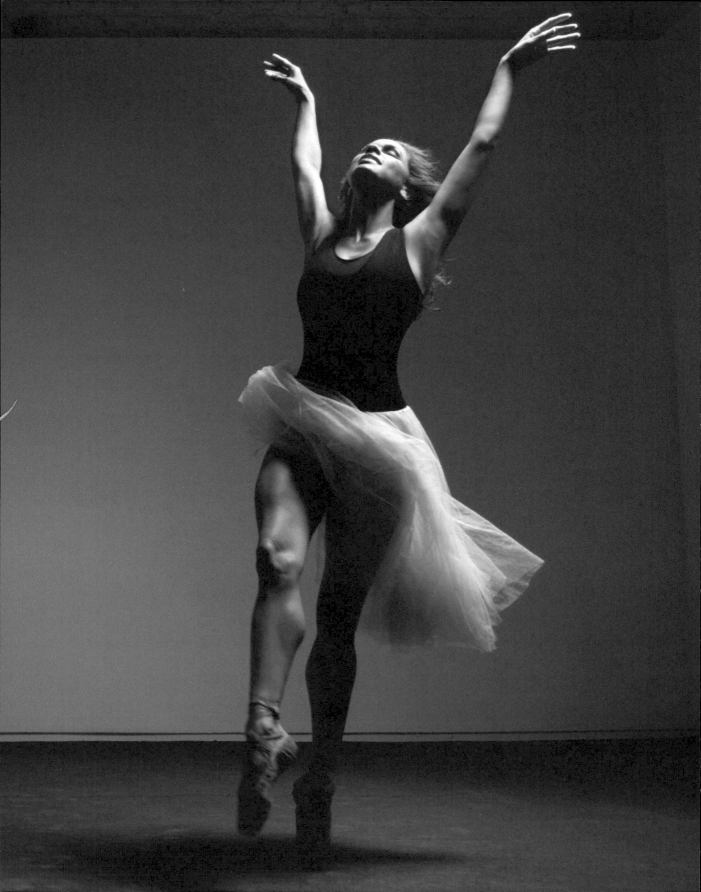

PHOTOGRAPHS BY RICHARD CORMAN

MISTY COPELAND

power and grace

INTRODUCTION

Nearly twenty years ago, I was teaching a free ballet class for disadvantaged children when I saw a quiet, thirteen-year-old girl sitting on the sidelines, watching the other children dance. I had to encourage her multiple times before she consented to come down to the barre and try her first ballet steps. Little did I know that those would be the first steps in an amazing journey for Misty Copeland.

After only a few classes, I could see that Misty had the ability to become a professional ballerina. She had the perfect physique, even the perfect feet, for ballet. Misty soon joined our ballet school as a scholarship student, training every afternoon. She was a ferocious learner, quickly catching up to and surpassing dancers who had started much younger and trained much longer. Her fluid ability, musicality, grasp of technique, and flexibility were blindingly apparent. Far less apparent were Misty's thoughts and feelings.

Eventually, Misty moved into our home, sharing a bedroom with our young son, in order to continue her training. As she became not just a student, but also a member of our family, I increasingly realized the extent to which she kept so much of herself buried deep where others could not see it. Her dance ability spoke volumes as she kept her emotions silent. Misty's siblings had nicknamed her "Mouse" because she was always the quiet one in the corner, a pattern she continued while living with us despite our best efforts to pull her out. She was so shy she wouldn't respond to questions, even if she knew the answer. On one memorable occasion, she panicked and abruptly

hung up on a reporter who had called to interview her. I told her then, "Misty, if you want to dance, you have to find your voice."

Misty's success as a professional ballerina has been remarkable—earning a position as a Soloist with American Ballet Theatre, dancing the Firebird in Stravinsky's *The Firebird*, and starring as Odette/Odile in Tchaikovsky's *Swan Lake*. Yet her accomplishments go beyond the physical craft of her dancing—she has found her voice, both on the stage and off.

At the moment she accessed her voice, Misty became a role model for all boys and girls to believe in themselves. In her, they can see that all things are possible. Misty's openness about the challenges she faced as an African-American ballerina and her passion to bring more diversity to the world of classical ballet have inspired countless young dancers and attracted new audiences to theaters across the country. Her ongoing efforts to raise awareness of the unique challenges faced by dancers of color have enriched her life and made all of us who know and love her incredibly proud. In finding her voice, Misty truly is achieving her goal to open doors in the world of dance for the "little brown girls."

Misty's journey should inspire all of us—not only that we have tremendous inner potential to achieve our dreams, but that whatever we feel passionate about, we can find a voice to change the world.

<div align="right">

—Cindy Bradley
Artistic Director, San Pedro City Ballet

</div>

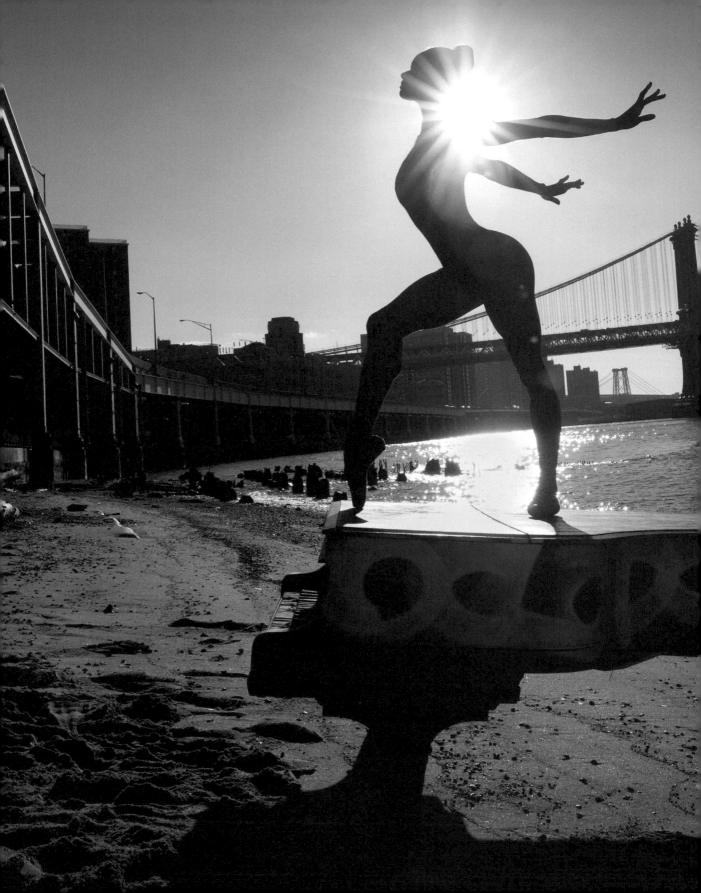

I WAS BORN TO MOVE.

I'm 5'2",
I started when I was 13,
I'm black,
but I've made it happen.
I'm very lucky
to be where I am....
it's possible.

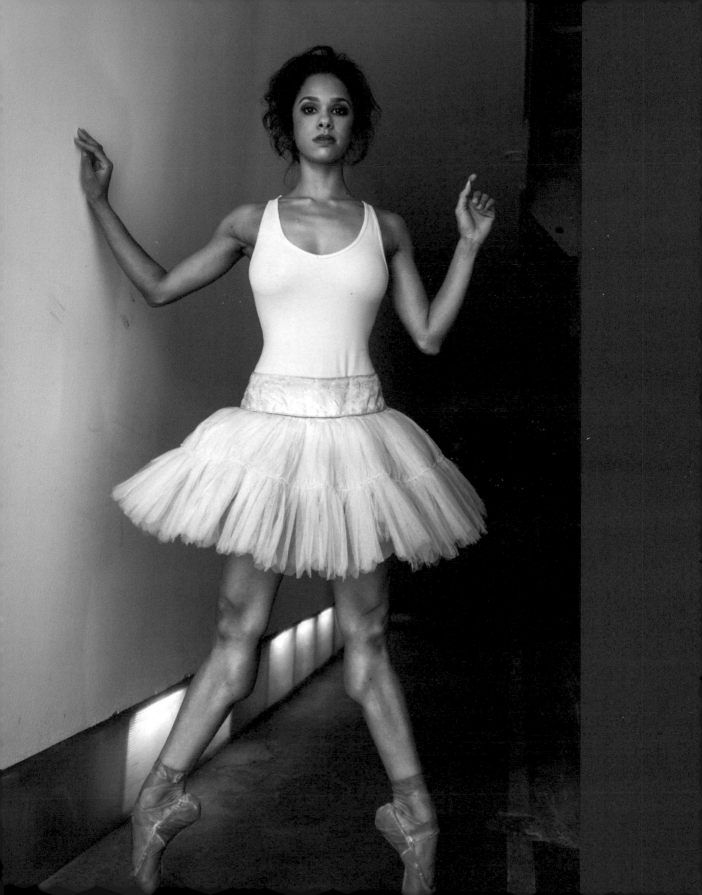

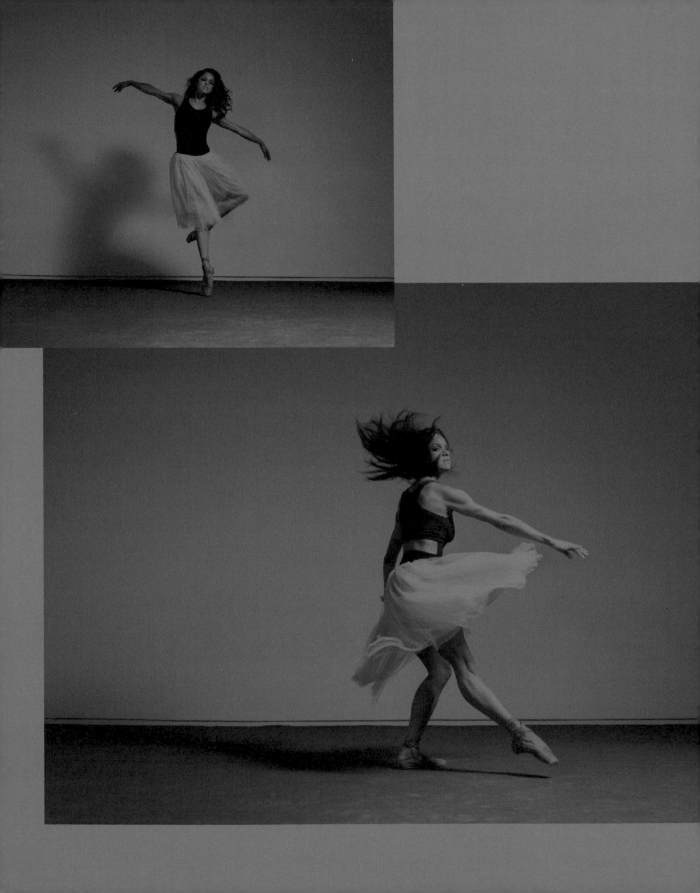

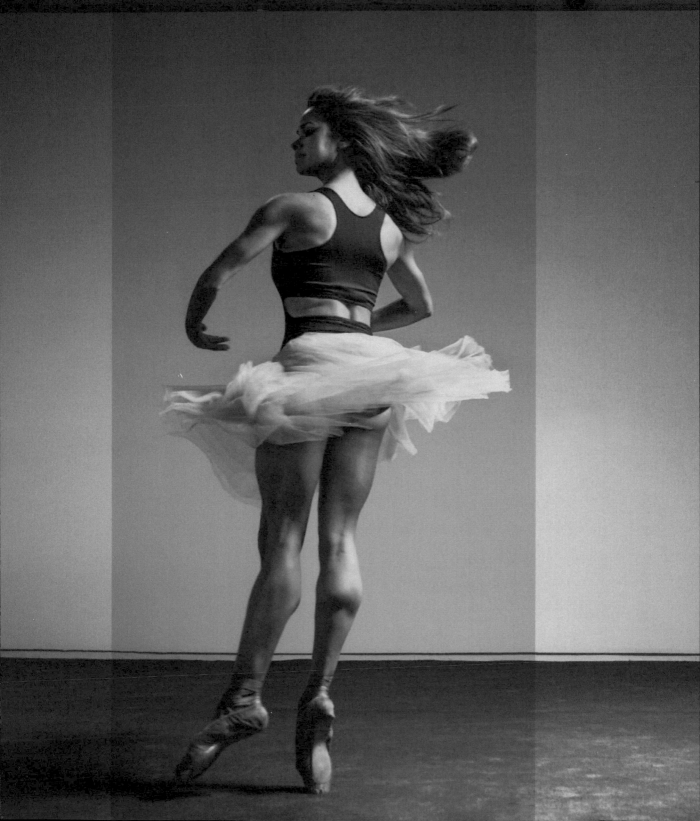

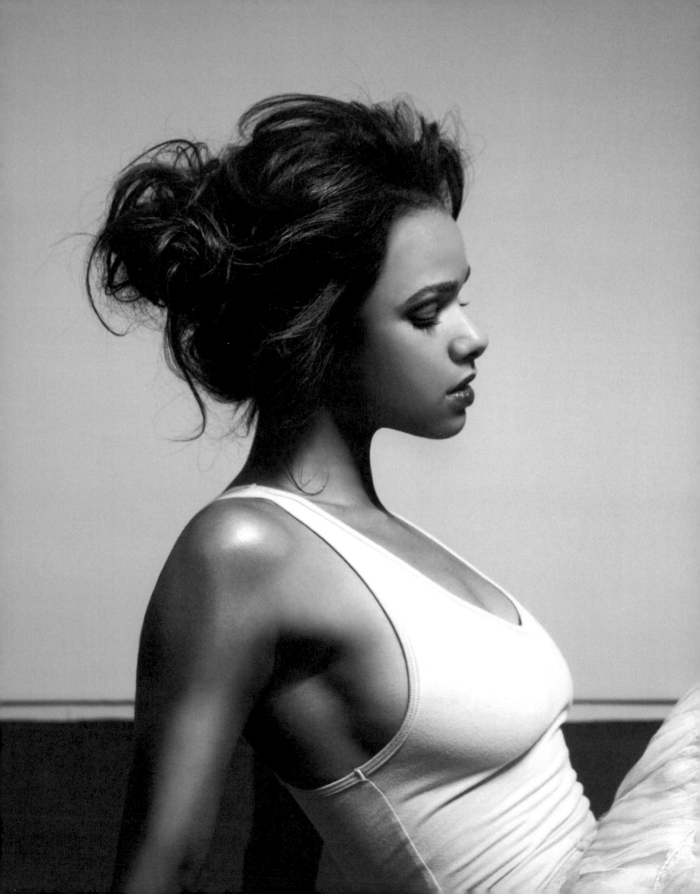

If you can make
it through the
second
act of Swan Lake,
you can
do anything.

Ballet ... something pure in this

crazy world.

*I am
proof that it's
possible and we can be part
of this culture and I am pushing
constantly to promote diversity
in classical ballet.*

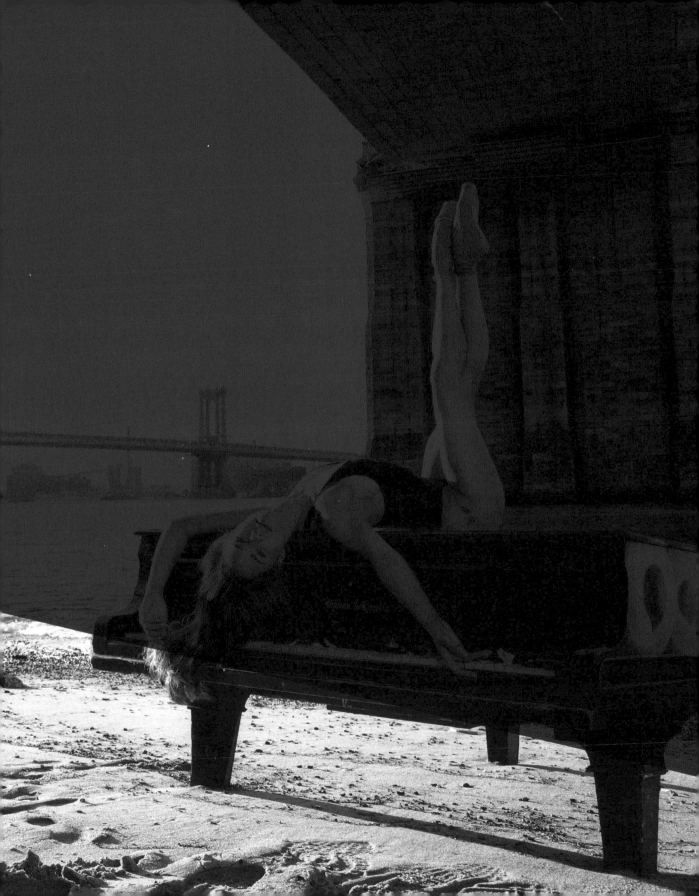

The greatest lesson I've learned is to be vulnerable and

believe in myself.

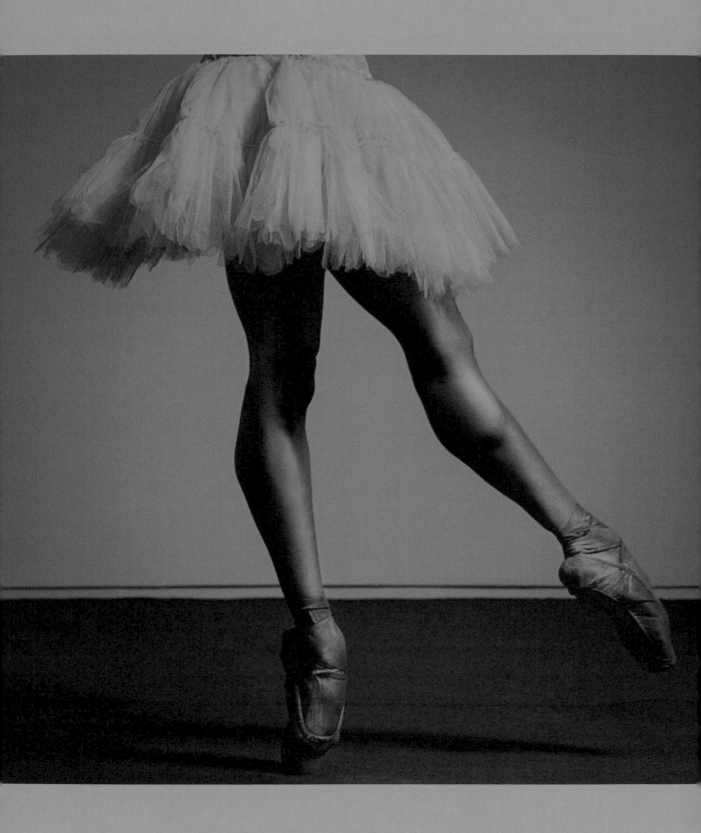

YOU CREATE YOUR DESTINY.
HARD WORK, DEDICATION,
SACRIFICE, AND TAKING
RISKS CREATE AMAZING
OPPORTUNITIES.

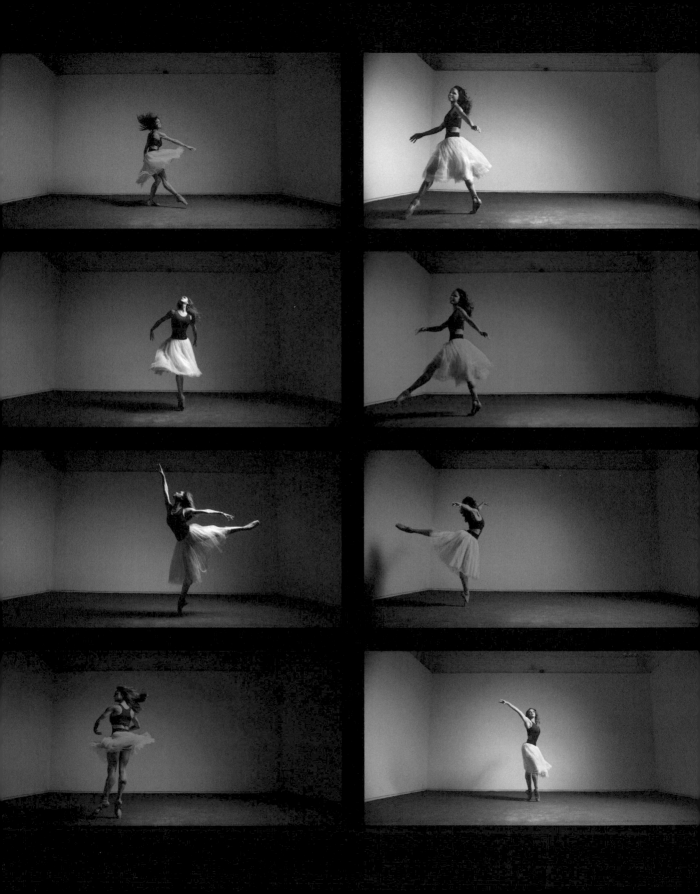

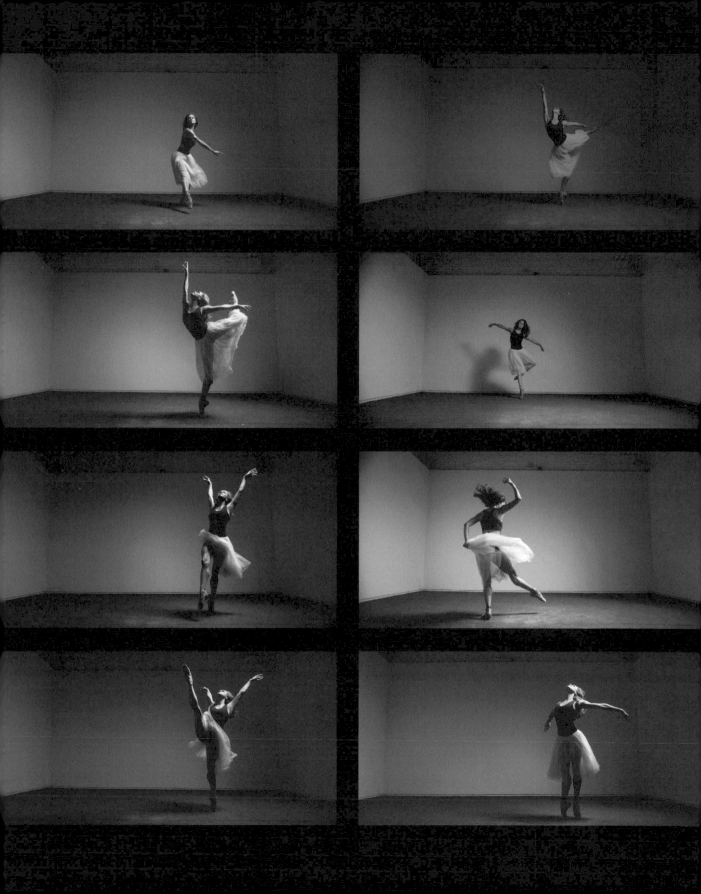

FINDING YOUR POWER DOESN'T HAVE TO BE SCARY.

INSTEAD, IT MAKES YOU FEEL IN CONTROL,

STRONG, AND PROUD.

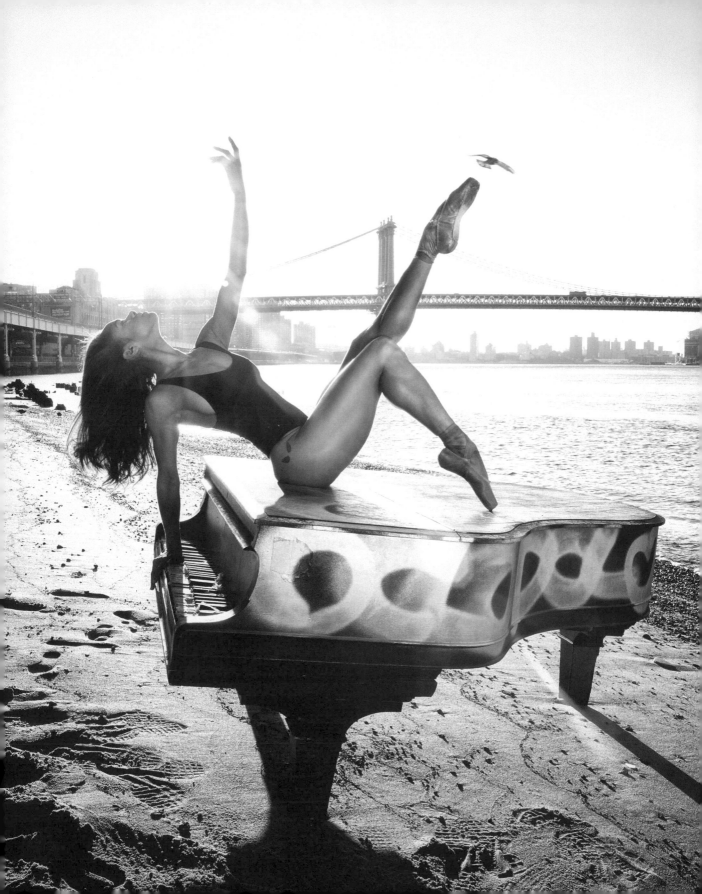

BLACK GIRLS DO ROCK AND BLACK GIRLS CAN BE BALLERINAS.

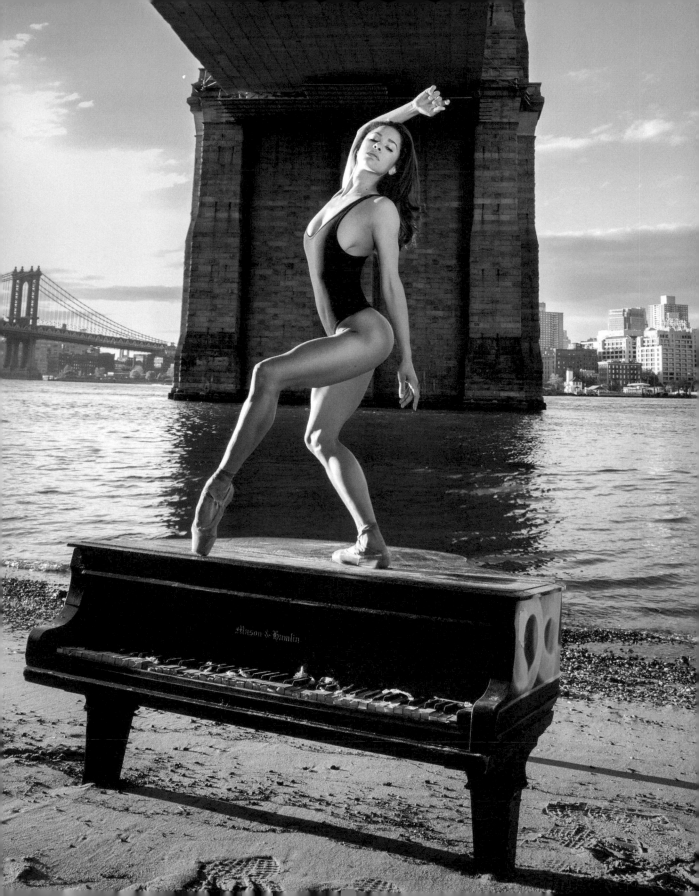

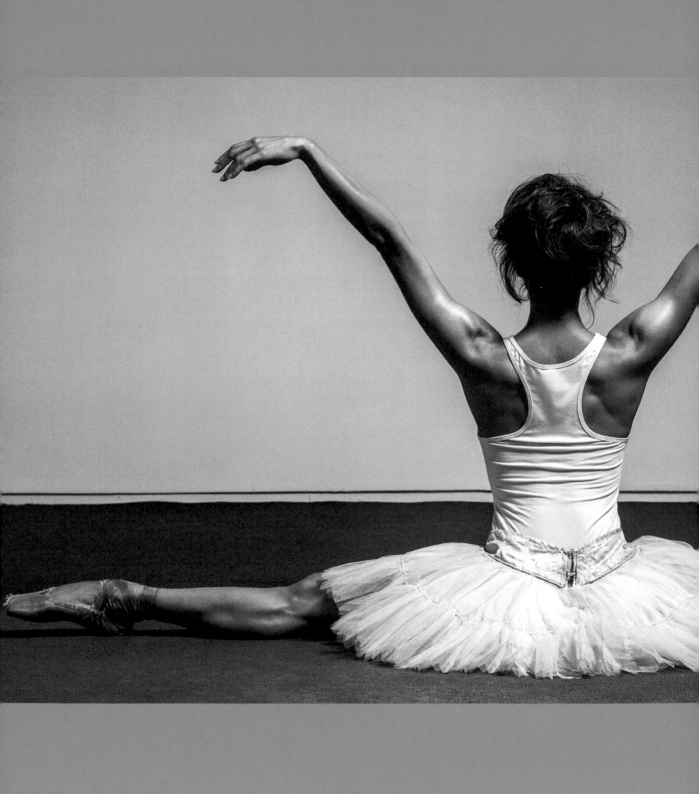

THE PATH TO SUCCESS IS NOT AS FIXED AND INFLEXIBLE AS YOU THINK.

Even to this day I hear that
I shouldn't even be
wearing a tutu, I don't have
the right legs, my
muscles are too big.

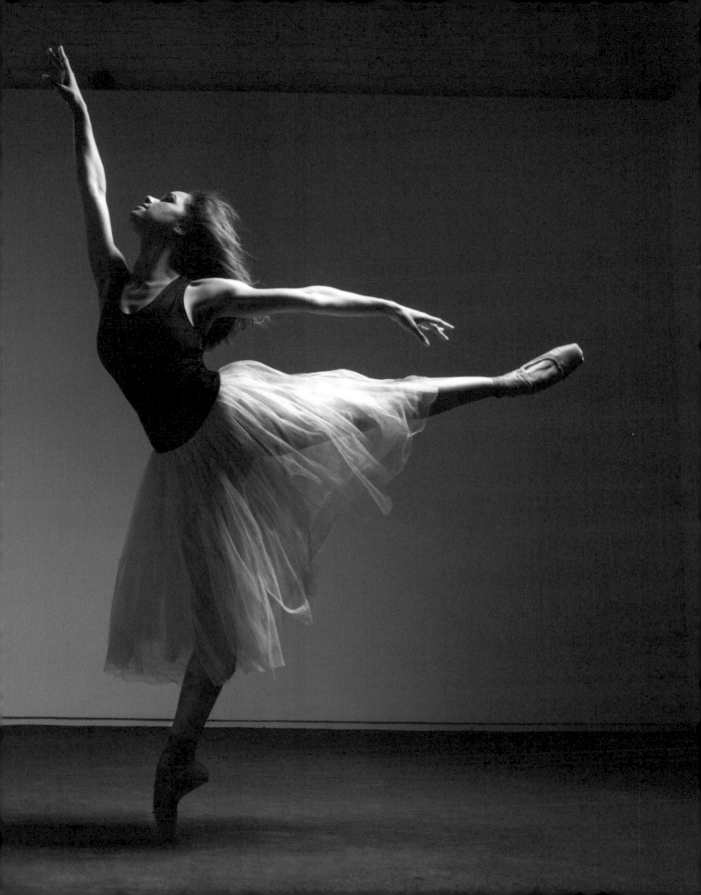

I think it's so important for young dancers of color to have someone who looks like them as an example—someone they can touch.

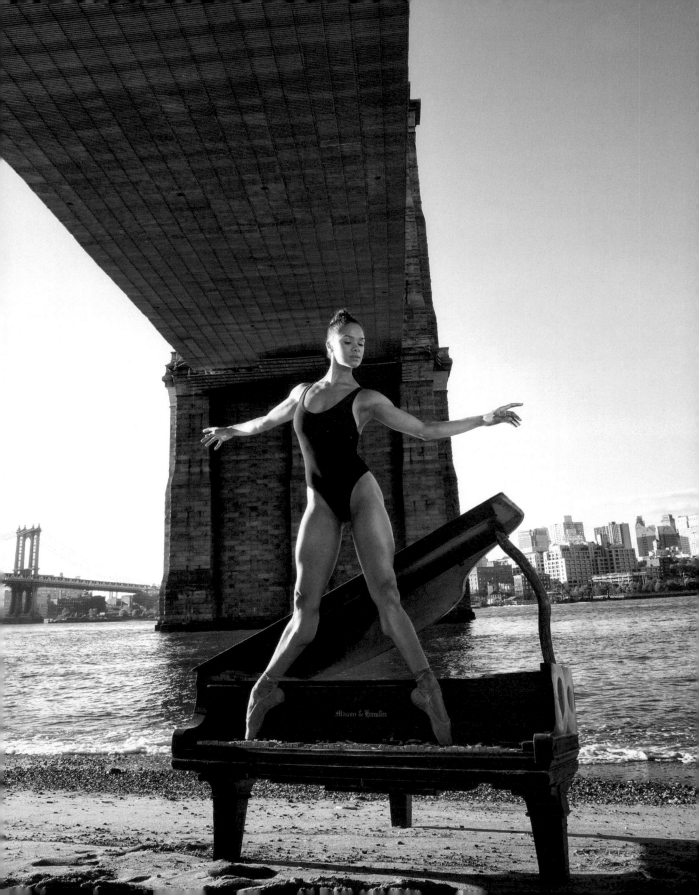

SUCCESS ISN'T HANDED

TO US; WE EARN IT.

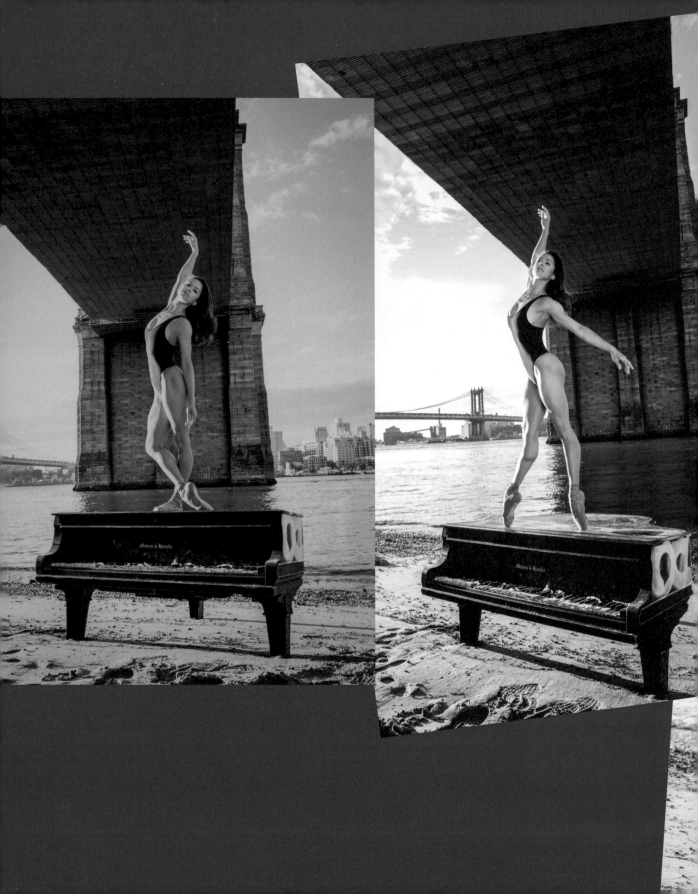

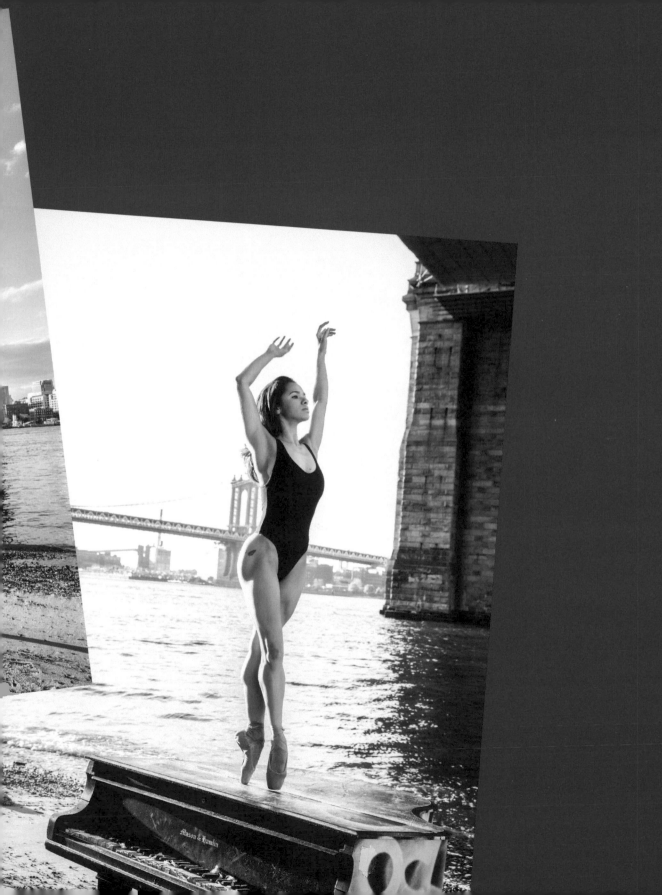

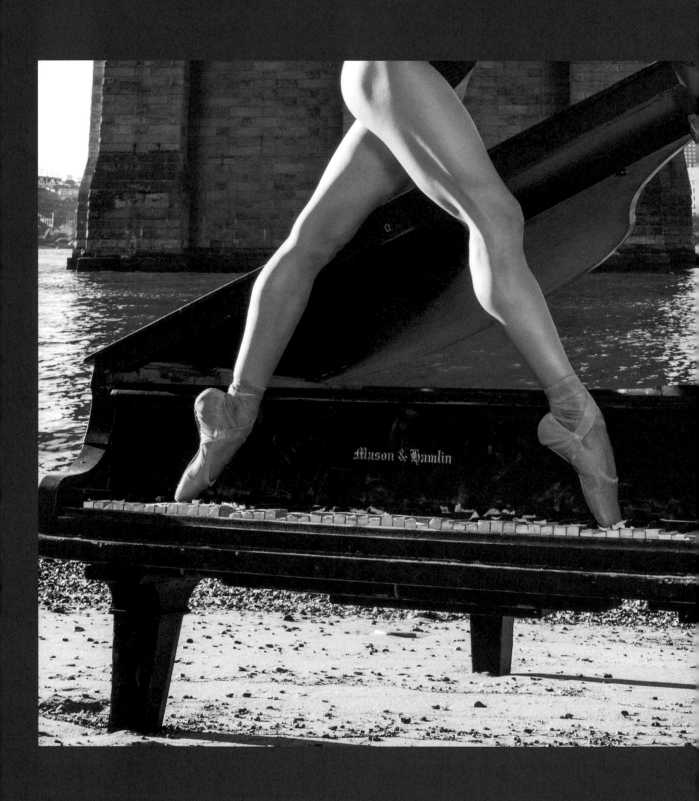

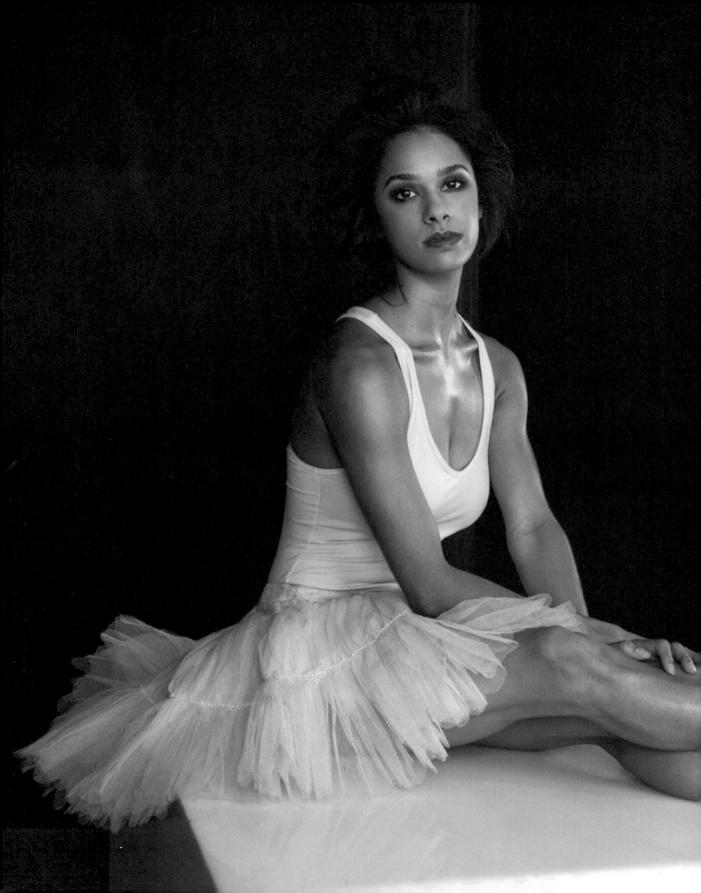

I just try to approach every opportunity on stage as if it's my first time and my last time.

I've come so far from

the first ballet class I took at age 13 in

my baggy gym clothes

at the Boys & Girls Club ...

I will forever fight,

performing like it's my last show.

And I will love

every minute of it.

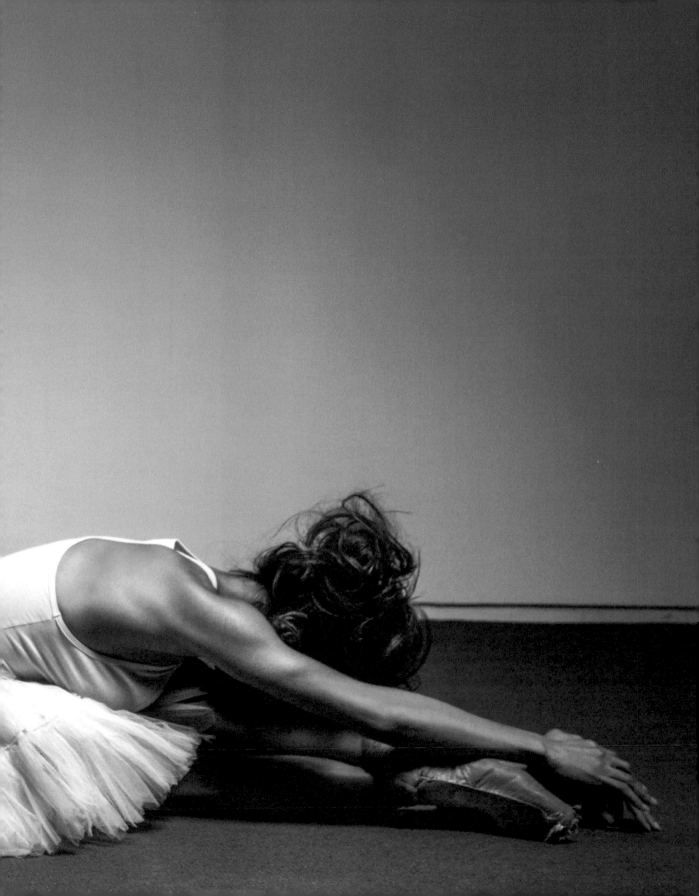

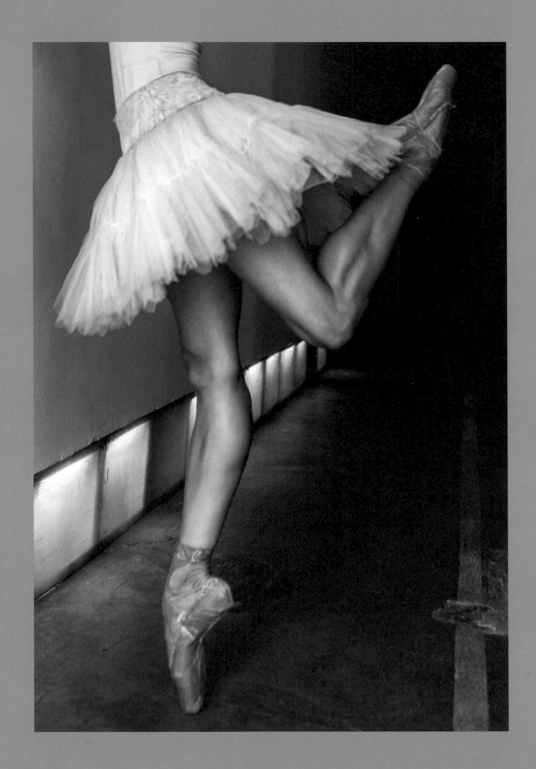

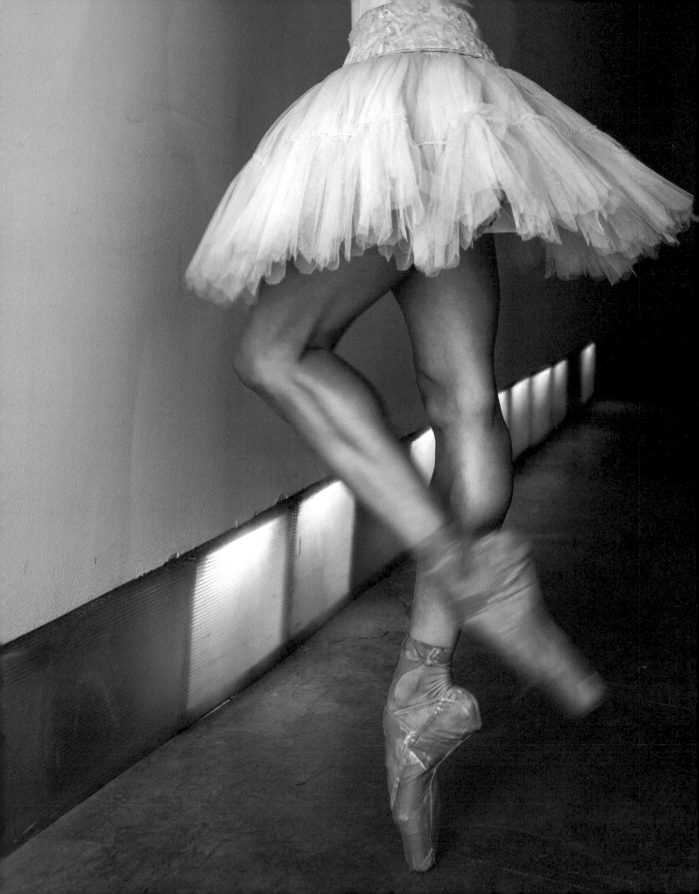

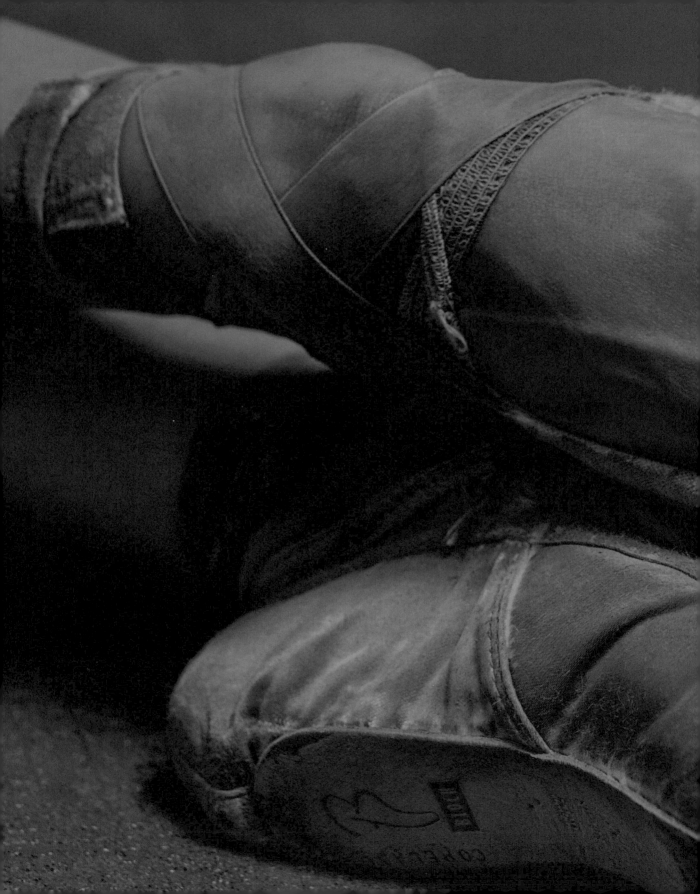

I NEVER SPOKE AS A CHILD. IN DANCE,
BALLET WAS THE FIRST TIME I
FELT REALLY POWERFUL AND THAT I WAS
STRONG AND CONFIDENT.

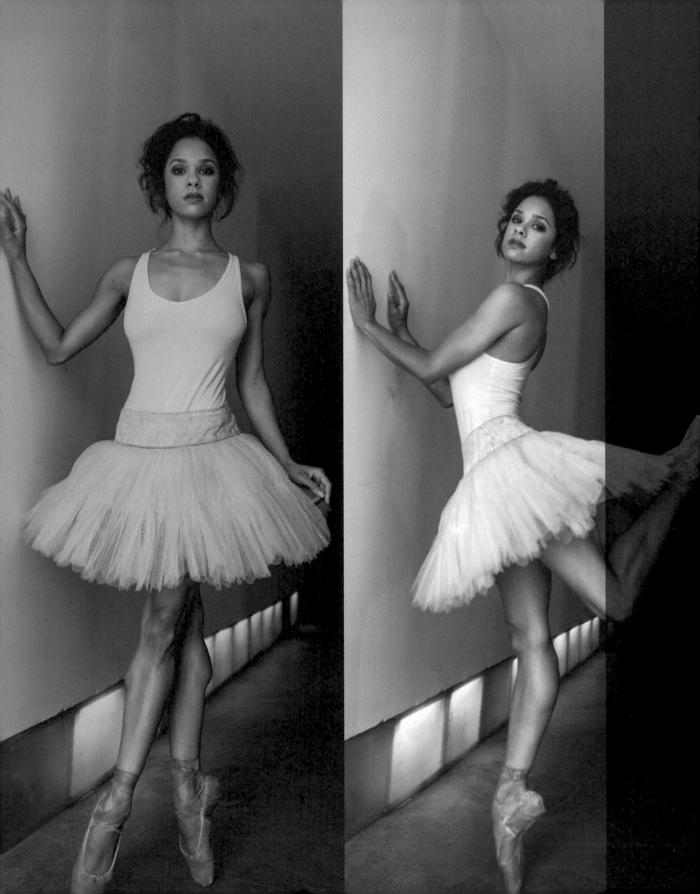

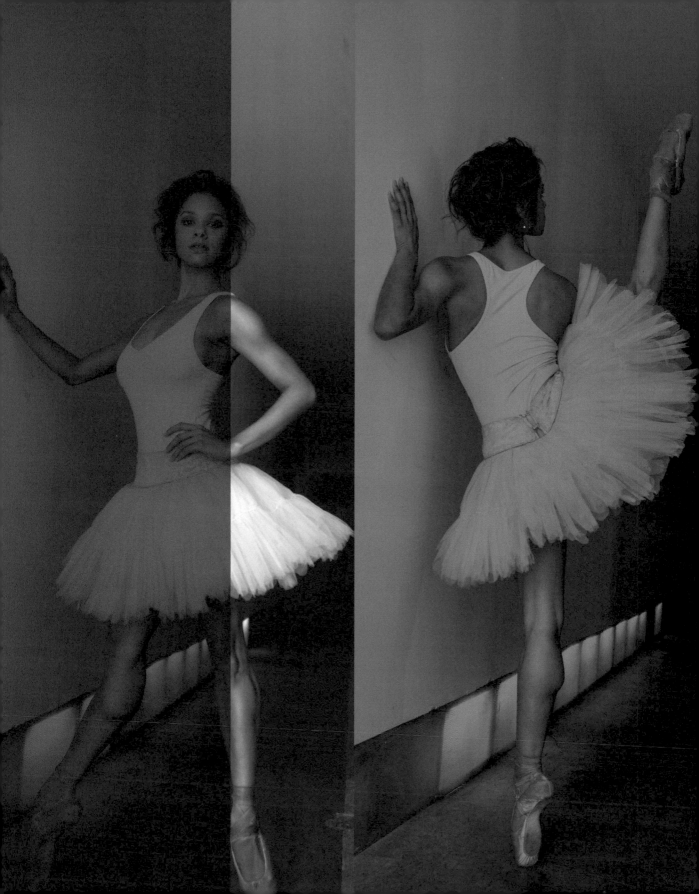

THIS IS WHAT I'M MEANT TO DO. THIS IS WHAT I'M GOING TO DO. I'M GOING TO MAKE IT SOMEHOW.

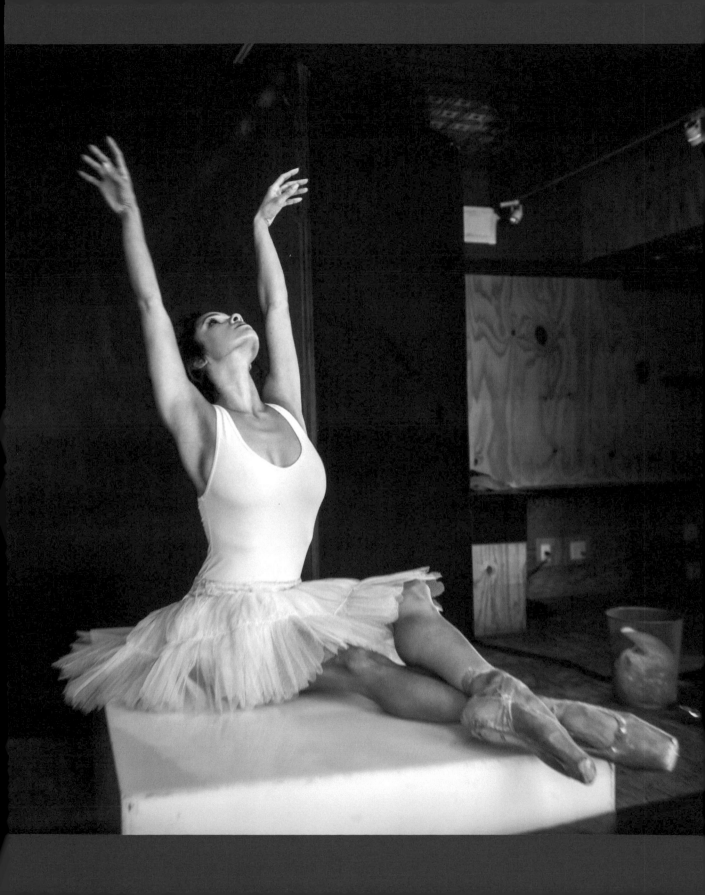

My body is very different

from most of those I dance with.

But I didn't let that stop me.

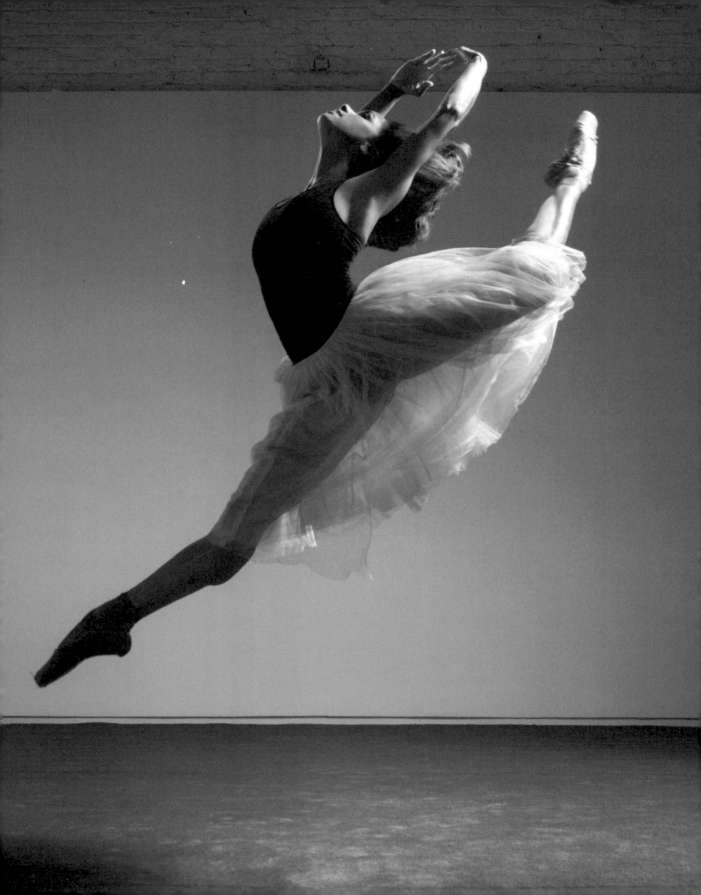

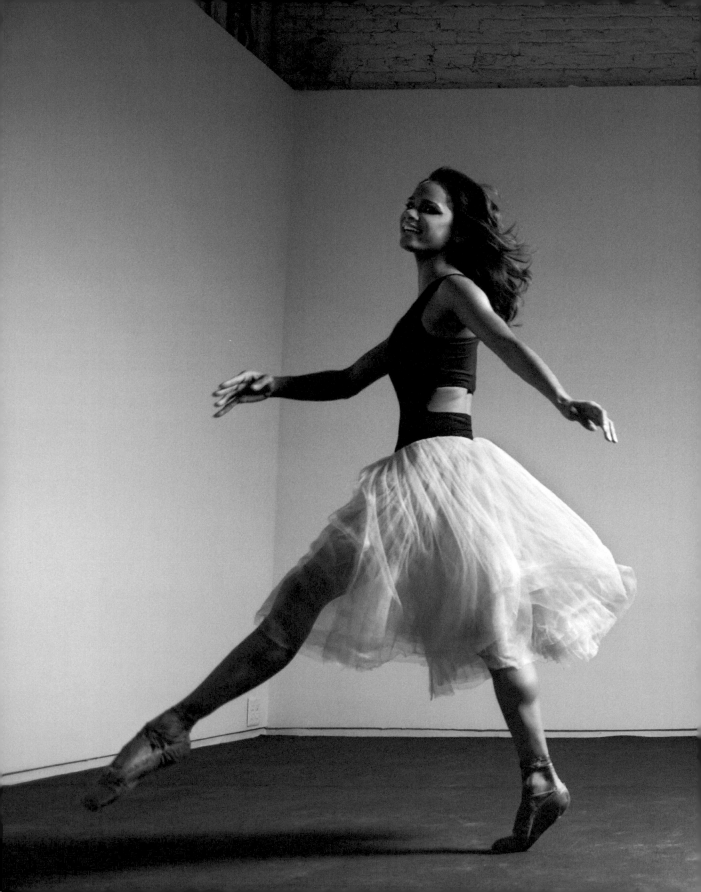

PRACTICE DOESN'T MAKE PERFECT.

PERFECT PRACTICE MAKES PERFECT.

At this point in my career, having the platform that I have to speak about diversity, I'm motivated by all of those young dancers who can see themselves through me. It's about creating a new dream and possibility for them, and that's what drives me to keep dancing.

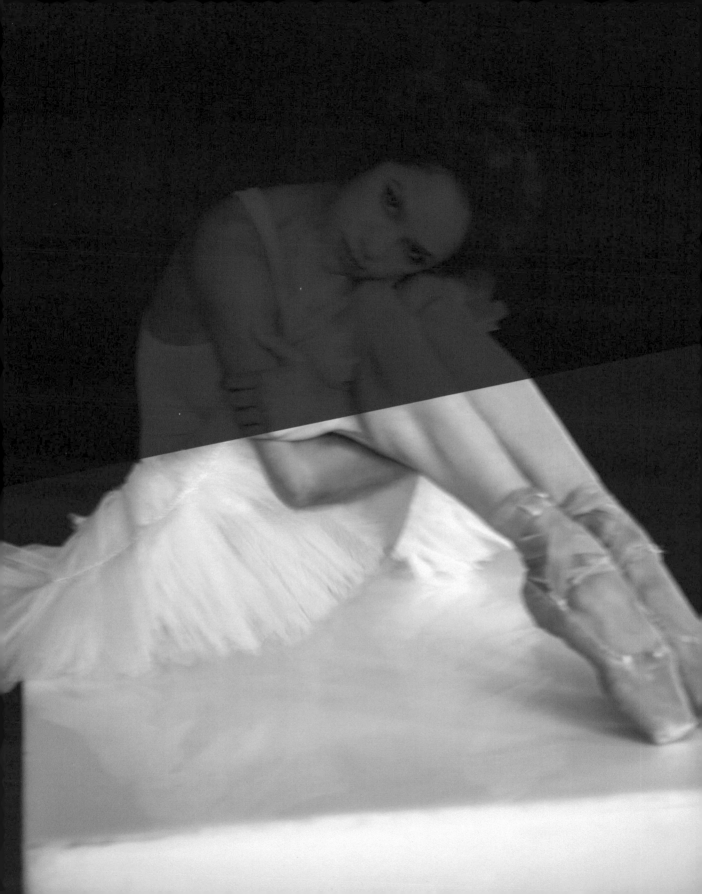

I thank my friend, Sean James, whose organization, BE IN THE KNOW ABOUT BULLYING, is providing our youth with skills and knowledge that foster self-confidence and self-empowerment through leadership, education, and the use of meaningful mentors.

www.knowaboutbullying.com

Photographs © 2015 Richard Corman
Introduction © 2015 Cindy Bradley
All quotes attributed to Misty Copeland

ISBN: 978-0-692-49323-6 (pbk.)
ISBN: 978-0-692-49325-0 (e-book)
Library of Congress Control Number: 2015944969

For ordering information, contact Ingram Publisher Services Inc.
Design: Yolanda Cuomo Design, NYC
Associate Designer: Bonnie Briant
Assistant Designer: Bobbie Richardson

MICHAEL FRIEDMAN GROUP INC.

1140 Broadway, 14th Floor

New York, NY 10001

CPSIA information can be obtained at www.ICGtesting.com
Printed in the USA
BVIW12n1237300715
411166BV00001B/1